HOW TO RECOGNIZE

Egyptian

ART

D0974279

PENGUIN BOOKS

Author Professor Giorgio Lise
Idea and realization Harry C. Lindinger
Graphic design Gerry Valsecchi
Artist Mariarosa Conti

Contents

Penguin Books, 625 Madison Avenue, New York, New York 10022
Penguin Books Canada Limited, 2801 John Street, Markham, Ontario, Canada L3R 1B4

First published in Italy by Rizzoli Editore, Milan, 1979
First published in Great Britain by Macdonald Educational Ltd 1979
First published in the United States of America and Canada by Penguin Books 1980

Printed in Italy by Rizzoli Editore

Introduction

Of all the Mediterranean cultures, that of ancient Egypt was by far the most long-lived, since it developed over a good three thousand years. The standard chronology used to classify the art that it produced covers historical times, as distinct from the preceding millennium, with its already sometimes highly developed art forms, and is divided into periods according to the various dynasties: the Early Dynastic, or Archaic, Period (3100–2686 BC, 1st–2nd dynasties), which began with the unification of Upper and Lower Egypt; the Old Kingdom (2686–2181 BC, 3rd–6th dynasties); then the First Intermediate Period (2181–2133 BC, 7th–10th dynasties), during which time centralized government broke down; and the Middle Kingdom (2133–1786 BC, 11th–12th dynasties), followed by the Second Intermediate Period (1786–1567 BC, 13th–17th dynasties), when Egypt was ruled by Bedouin princes whom ancient Egyptian propaganda painted blacker than they were. The country was freed and unified by Ahmose, founder of the 18th dynasty, which marked the beginning of the New Kingdom (1567–1085 BC, 18th–20th dynasties), the golden age of Egyptian civilization which covered the reigns of some of Egypt's greatest kings, bearing names like Amenophis, Tuthmosis, and Ramesses. A period of intermittent decadence, known as the Late Period, began with the 21st dynasty and continued up to the Roman conquest.

The most characteristic feature of Egyptian art was its unity of style and purpose. This was so even during periods of decadence, as well as at times of intense cultural revival, for example during the 26th dynasty, or Saite period, named after Sais, the town of that dynasty's origin. The unifying element was the king's, or pharaoh's, court, comprising both the secular machinery of the state, and that of religion. The latter was closely bound up with the principle of the divinity of the sovereign, who was considered to be the living aspect of the sky-god Horus, traditionally represented as a falcon. The sovereign had to guarantee by his power the unity of a country

3

Royal patronage

► The Sphinx of Giza, an enormous figure with a lion's body and human head. It has the facial features of the 4th-dynasty pharaoh Chephren and was carved out of limestone to stand guard over his funerary buildings. The figure, measuring about 57m long and 20m in height, has a small alabaster temple between its paws, and backs on to the pharaoh's mortuary temple, which lies next to the royal pyramid.

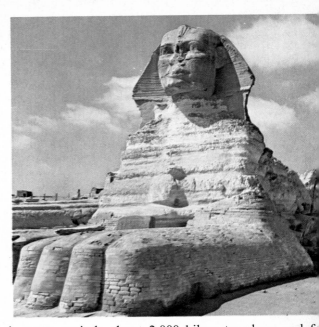

in some periods about 2,000 kilometres long and for much of its length only about 30 kilometres wide. He was involved in the production of many works of art, either because he had commissioned them or as the source of inspiration. The artist himself was seen merely as a anonymous craftsman, while the glory of his work reflected on the person who commissioned it. Painters and sculptors were looked on as artisans rather than creative artists and admired merely for their dexterity. Only architects were thought of as intellectual workers.

The range of surviving works of art from ancient Egypt includes great architectural and sculptural monuments and shrines, together with a multitude of paintings and other ornaments. It also features a tradition of splendid handwriting and inscription. This was a highly individual art form and was often decorative rather than functional. Reliefs and wall paintings were accompanied by inscriptions which either described the events and the human and divine figures depicted in them, or gave ancient religious and magic formulae, many of which had evolved over thousands of years before the development of writing and the beginnings of Egyptian history.

Wall painting from the tomb of Pharaoh Horemheb (18th dynasty). The king is wearing a linen head-dress, or *nemes*, decorated with the sacred cobra, and stands opposite the hawk-faced figure of the god Horus. The name 'Horemheb' ('Horus is in festival') is given in the first oval shape on the left.

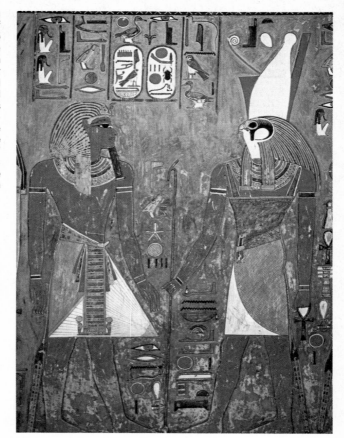

Stone tablet with hieroglyphic inscription commemorating the founding of a temple to Amen, king of the gods. It also gives the forename, taken at his coronation, of Ramesses II, and the pharaoh's family name, together with the standard attributes of the kings of Upper and Lower Egypt.

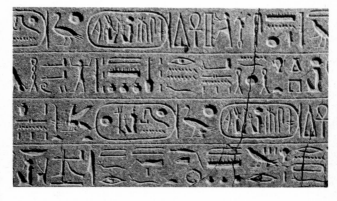

5

Architecture

The ideological basis of Egyptian art was the glorif
cation of the deified pharaoh, and magnificent funerar
temples and sumptuous tombs decorated with sculpture
and reliefs were built for him. Whole villages sprang u
to accommodate all the people needed for building suc
temples and tombs – masons, stone-cutters, quarr
workers, sculptors, wood-workers, and priests.

A preoccupation with the gods and their symbols was
dominant feature, from the overall planning down to th
smallest detail. The temple was the house of the deit
who resided there day and night; so his statue wa
adorned and symbolically nourished by the priests. Th
whole temple was decorated with relief carvings, picture
and inscriptions illustrating the relationship between th
deity and the pharaoh who had built his house.

At the beginning of the dynastic period the mo
characteristic piece of architecture was the mastaba,
type of flat-topped tomb built for the monarch on th
desert escarpment at Saqqara, a short distance above th

▼ The building type
of the step pyramid
developed from the
flat-topped mastaba
tomb, and its
earliest version in
fact consisted of a
series of mastabas
of decreasing size,
one on top of the
other.

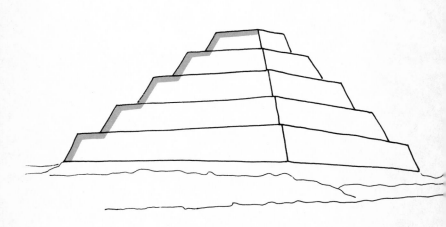

apex of the Nile delta. During the Old Kingdom when the monarchs were buried in pyramids the nobles adopted the mastaba-form for their own private tombs, for example the rows of them at Giza near where the city of Cairo was later established. In the centre a shaft led down to the cell where the sarcophagus was placed. There were generally two areas in the main body of an Old Kingdom mastaba – the shaft, which was filled with stones once the sepulchre had been walled in, and, at ground level, a chapel. Inside it were the altars, funeral offerings, multi-coloured reliefs or wall paintings with scenes of everyday life, and inscriptions with religious formulae aimed at securing an everlasting magical food supply from the gods of the necropolis, or burial area, like the dog-headed god Anubis (see p. 52), and Osiris, god of the dead (see p. 51). Some mastabas also had other decorated rooms, including one with a 'false door' or funerary pillar (see p. 23), with a stone table in front of it for offerings.

But of all architectural types of structure built during the Old Kingdom the most remarkable was the pyramid, the huge stone mound described by one early traveller as the 'granary of Egypt'. The name comes from the Greek

▼ The earliest of the pyramids is that of the pharaoh Zoser at Saqqara (3rd dynasty, *c.* 2650 BC). It is thought to be the work of the architect Imhotep. The pyramid stands about 60m high in the middle of an enclosure built to contain funerary chapels. The chapels in the foreground commemorate *Hebsed,* the pharaoh's jubilee.

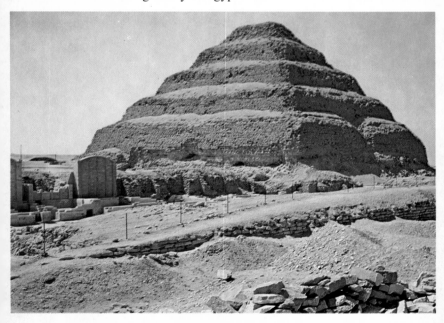

The pyramid

▼ The development of the pyramid in time produced a straight-sided structure with the earlier steps incorporated into a completely smooth covering. The most famous pyramids of this type are those at Giza, near Cairo, which date from the 4th dynasty.

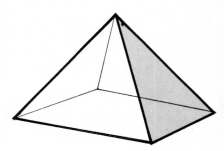

pyramis, meaning a type of wheaten cake. The building type itself is now believed to have symbolized the sun, the highest divinity in the land of the Nile. Pyramids were usually intended as royal tombs, although in a few cases one pharaoh had several pyramids built, the reason for which is not altogether clear. One generally accepted idea that needs to be re-examined concerns the millions of slaves allegedly used to build the pyramids. As the Egyptian economy was primarily agricultural it would not have been able to feed them all. It is more likely that in the long spells when there was no farm work to do, during the regular rises in the level of the Nile, numbers of Egyptian people were taken on to build these enormous stone mounds.

The system for engaging thousands of people otherwise with nothing to do for months on end may have been devised by Imhotep, the outstanding architect who, during the reign of the 3rd-dynasty pharaoh Zoser, built at Saqqara the first pyramid, known as the Step Pyramid because of its shape. His efficient system of organization even provided for living quarters near at least one site for thousands of workers.

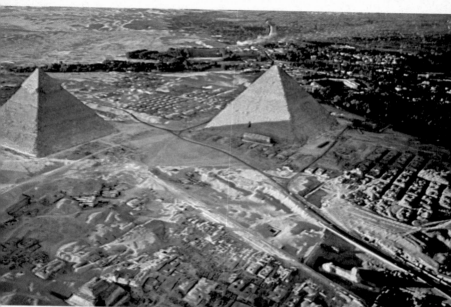

▲ The complex of buildings at Giza consists of the pyramids of Cheops, Chephren, and Mycerinus and was built between about 2600 and 2500 BC. This aerial photograph also gives a good idea of the layout devised for the surrounding burial complex.

The form of the pyramid varied. As well as the stepped version at Saqqara and the classical shape of pyramid at Giza, for instance, there was also the bent pyramid, such as the one dedicated to the 4th-dynasty pharaoh Sneferu at Dahshur, a few kilometres south of Giza. In this type of pyramid the slope of the sides increases sharply halfway up, giving the building a crushed look. To ensure that the building was stable it was built on a stone base with the foundations sloping inwards slightly. This meant that the enormous mass of wall could not cause the building to collapse by pushing outwards, which is what happened if the stones were not absolutely square. The danger of this became even greater when larger blocks of stone began to be used (the first pyramid had been built with small blocks, reminiscent of the clay bricks used earlier).

The pyramid was only part of the whole funerary complex, including a temple on the eastern side of the pyramid and another a bit lower, towards the river, connected by a covered and raised causeway. Inside the pyramid a series of corridors led to the main room, which was intended for the body of the pharaoh, and to other

Funerary temples

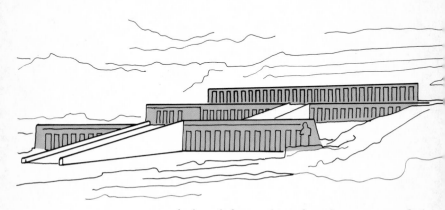

rooms, designed for various functions, some of them built below ground level.

The funerary temples, for the worship of the dead pharaoh, were made of stone, with square pilasters, or projecting columns, and massive architraves, or horizontal mouldings, marking out the rather small dark rooms (a typical example survives at Memphis). The temples consisted of an entrance hall; one or more pillared, or hypostyle, halls; a courtyard with statues; one or more chapels; and the actual sanctuary. Round the main pyramid were other smaller ones, for the king's family. The most famous complex is at Giza, with the pyramids of the 4th-dynasty pharaohs Cheops, Chephren, and Mycerinus, plus Chephren's colossal sphinx. Within the earlier temples it was during the 5th dynasty that columns with capitals – the part of the column at the top of the shaft – began to be made in the form of palm leaves and lotus flowers. The columns themselves were generally symbolic representations of tree trunks or bundles of stalks of local plants. If the shaft of the column was carved with several stalks, horizontal

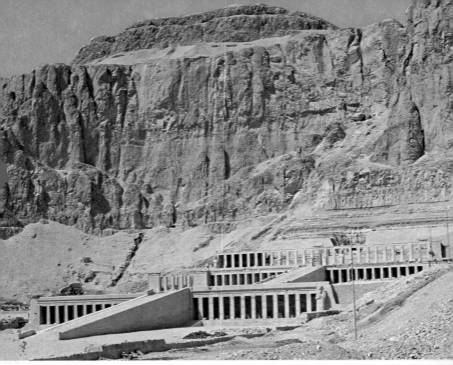

▲ The funerary temple of the 18th-dynasty queen Hatshepsut at Deir el Bahri. This majestic complex, the work of an architect called Senmut, blends well with its site, consisting of three descending colonnades linked by ramps. A central chapel is carved into the rock at the top.

bands would be added, giving a naturalistic effect of stalks bound together. Other representational features included palm tree columns, with a circular shaft and the capital in the form of stylized open palm leaves; lotus columns, with the shaft looking like bound stalks and the capital in the form of a closed lotus flower; and papyrus columns, in earlier forms with ribbing and tapered at the base, and with the capital in the form of a papyrus flower with a closed calyx. The papyrus column later developed into the bell-shaped or 'campaniform' column, with an open flower and no ribbing, and the monostyle column, with an unribbed shaft and plain capital.

Although there are early examples of monolithic columns – columns shaped, that is, from one block – including some in granite, in Egyptian architecture columns were so huge that they were generally made of blocks placed one on top of the other. These were then surmounted by a capital with a plant motif. The shafts were decorated with carved reliefs, including both figures and inscriptions, and were originally multi-coloured, in red, blue, and yellow.

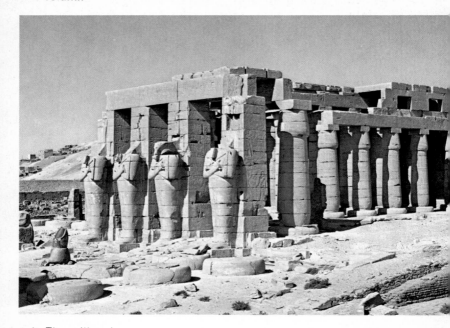

▲ ▶ The pillared hall of the Ramesseum, the funerary temple of Ramesses II (19th dynasty) in the burial complex at Thebes. Four colossi portraying the king as Osiris, each 9m high, stand in front of the hall.

Almost as old as the pyramids themselves are the surviving Egyptian temples; but remains of this building type exist only from the Middle and New Kingdoms. The temple gradually developed into an original tri-partite structure based on the very simple plan used for private houses. An entranceway led into a reception room and then into a third room, as in a private house. A colonnaded courtyard then led into a hypostyle hall and a sanctuary.

Whereas it is easy to pick out the pyramid as the most typical piece of architecture in the Old Kingdom, little Middle Kingdom architecture has survived, especially as

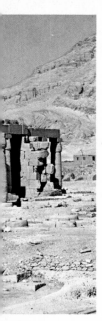

▼ These surviving columns stand behind the pylon (the truncated towers in the background) in the temple of Ramesses II at Luxor. They have typical cushion-like bases and the shafts are in the form of the stalks of lotus flowers. The capitals are each carved to look like a closed lotus flower.

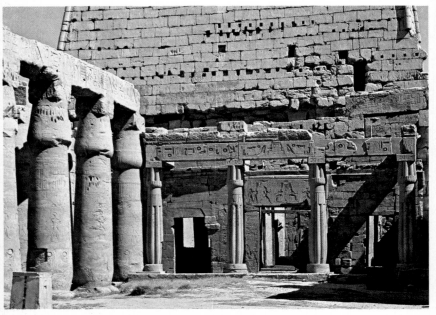

▲ This form of façade, with a trapezoid tower on either side of an entrance, was common in consecrated buildings of the New Kingdom. Such sites also frequently included obelisks in front of the entrance and large statues of gods and pharaohs set against the walls.

many of the buildings were incorporated into later structures, as in the temple complex of Amen, king of the gods, at Karnak. Other temples were left to decay and in the Christian era were turned into churches. The only 12th-dynasty building that has survived intact is the pavilion of Sesostris I (see p. 21) at Karnak (*c.* 1970–1925 BC), now in the north-west corner of the enclosure of the temple of Amen. This little shrine was reconstructed in modern times by an architect who salvaged the original components, which the 18th-dynasty ruler Amenophis III had used for the foundations of the third pylon, or pair of truncated pyramids, within the large temple itself. The pavilion was built on a square plan and supported by sixteen quadrangular pillars, and is entered from two ramps forming an axis.

On the other hand, a number of large buildings of great architectural complexity have survived from the New Kingdom. By this time the structure of the temple had become more elaborate in order to meet the needs of religious practice. An access way, often lined with sphinxes, led up to the entrance front, which consisted of a façade formed by a portal within a pylon. Commemorative obelisks and seated royal figures were often placed

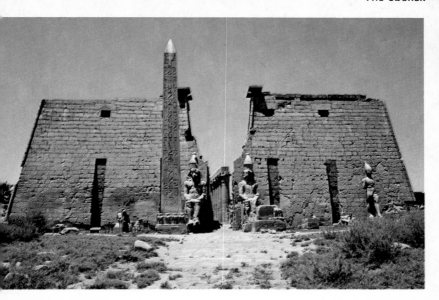

◄ The entrance to the temple of Amen at Luxor, which was built by Amenophis III (18th dynasty) and Ramesses II (19th dynasty). It was also Ramesses who had the two obelisks in pink granite from Aswan placed here (the missing one is in the Place de la Concorde in Paris), as well as the two statues of himself on either side of the entrance.

in front of the pylon; and beyond it was a large courtyard with lateral porticoes for the ordinary people, leading into a large enclosed pillared hall for the priests. A series of chapels surrounded the innermost part of the temple, which contained a sanctuary with the statue of the deity. The various parts of the temple were almost always placed along a single axis of symmetry; and the access way and the porticoes played a particularly important part in the processions that took place in the temple on the feast days of both major and minor deities. Inside the temple boundary walls were also sited the priests' dwellings, and the granaries in which foodstuffs from the deity's fields and from offerings were stored.

Several notable temples of this period are at Thebes, and date from the 18th dynasty, although extra parts were added to them throughout the New Kingdom. The most important one is dedicated to Amen and is at Karnak, on the eastern bank of the Nile at Thebes, north of modern Luxor. It was begun by Tuthmosis I in about 1523 BC, continued by Hatshepsut, Tuthmosis III, Amenophis III, Seti I, and Ramesses II and III, and was indeed modified down to the Roman era. It has a vast courtyard, a pillared hall with a double elevation – that

15

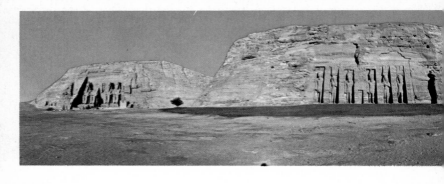

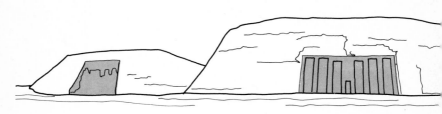

▲ The cliff temples at Abu Simbel, with the funerary temple of Ramesses II on the left, and that of his wife Nofretari on the right. The temple of Ramesses, which has four statues of the king set against the façade, goes back over 60m into the rock. Twice a year, at the equinoxes, the sun's rays would reach the innermost part of the temple, lighting up the statues placed there of the gods Amen, Re-Horakhti, and Ptah, and of the pharaoh himself.

is, the roof of the central aisle of the hall, resting on talle columns, is higher than the rest of the roof – and a complex sanctuary.

Another great Theban temple is at Luxor. This build ing was dedicated to the divine triad of Amen, his wife the vulture goddess Mut, and their son the hawk-headed Khonsu, and was mostly erected by Amenophis III, or the remains of a former sanctuary.

Of the funerary temples, the Ramesseum, built fo Ramesses II in Thebes, is one of the most impressive. I has two courtyards leading into a series of pillared hall and a further number of subsidiary rooms. Othe examples exist at Deir el Bahri opposite Karnak, and at Abu Simbel, far to the south and almost at the Second Cataract of the Nile. The earlier of the two funerary temples at Deir el Bahri is dedicated to Mentuhotep I, a sovereign of the 11th dynasty, and date from about 2000 BC. The other is dedicated to the New Kingdom Queen Hatshepsut, of the 18th dynasty, the most prominent woman ruler ever to have reigned as a full-scale pharaoh. Both temples are built against the mountain, and partly hollowed out into it, in an elaborate

▼ Two groups of statues flank the entrance to Nofretari's temple at Abu Simbel, with the queen herself placed beside her husband Ramesses II. The inscriptions on the pillars repeat the dedication of the temple. Recently both temples were hewn into blocks and moved higher up to prevent them from being submerged when the Aswan Dam was built.

terraced construction. The first temple consists of one terrace and had a pyramid surrounded by three rows of columns on the top, while the Hatshepsut temple is made up of two stepped terraces. Both temples are entered via inclined ramps. The Abu Simbel monuments include two interesting cult temples dug out of a cliff. The larger is dedicated to the deified Ramesses II and three major gods: Amen-Re, largely identified with Amen; Ptah, the creator god; and Re-Horakhti, identifiable with both Re, the sun god, and the falcon-headed Horus. The smaller is

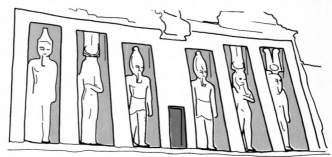

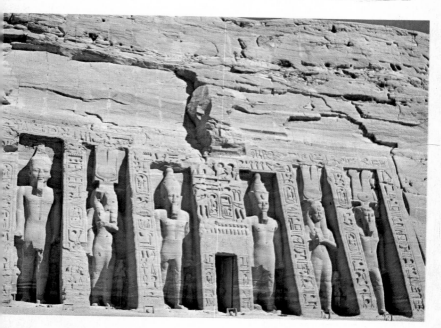

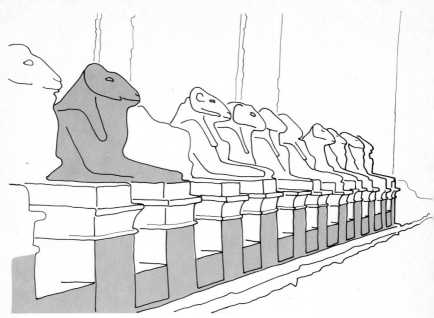

▲ Avenues lined by sphinxes with mainly ram's heads were a common feature of temples built during the New Kingdom. The shape of the bases reflect those of the pylon shown on p. 15.

dedicated to his wife, Queen Nofretari, and the goddes Hathor, often depicted as a cow. The façade of the large temple is 32m high and 36m long and is decorated wit four colossal statues of the sovereign. The first hall colonnaded and has eight large statues of Ramesses II a the god Osiris, and rooms at the side used for storage. courtyard with four columns leads to the sanctuary at th back of the temple. The façade of the smaller temple 27m high and 11m wide and features six statues arrange in pairs, representing Ramesses II, and Nofretari a Hathor.

Some architectural change can be seen during th reign of the 18th-dynasty pharaoh Amenophis IV, wh replaced the traditional worship of several deities wit the monotheistic cult of the sun god Aten. He changed h name to Akhenaten ('he who is of benefit to Aten') an had a new capital, Akhetaten ('horizon of Aten'), built o the site of present-day el-'Amarna, about halfwa between Thebes and the Nile delta. The temple of Ate consists of a pillared pavilion leading into three cour yards, a hypostyle hall, and a sanctuary, all arrange lengthwise. The ceremonies held there as part of the su

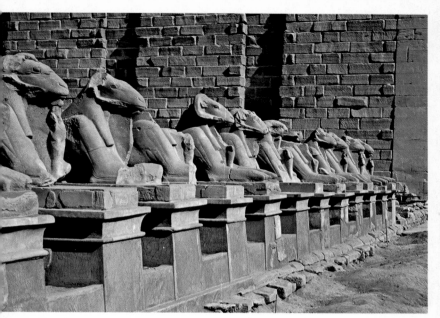

▲ The sphinxes lining the avenue leading to the temple of the god Amen at Karnak have lions' bodies and rams' heads (the ram was Amen's sacred animal). They each hold a statue of the god and the pharaoh between their paws.

cult took place in sunlight and not in the depths of the sanctuary, as with traditional religious ceremonies.

Also in religious building a further characteristic of Egyptian architecture was the obelisk. This was a monolithic pillar built on a square section, narrowing at the top to form a pyramid shape. Hieroglyphic inscriptions on the sides of these structures gave the name of the king who commissioned them and the event they commemorated. The origins of the obelisk went back a very long way to standing stones with a magic and symbolic significance and believed to have miracle-working powers. In Egypt they were principally used as a symbolic reference to the world's creation by the sun-god Heliopolis and were placed at temple entrances in such a way that they caught the first rays of the rising sun. They also symbolized the monarch's power and his or her piety towards Amen-Re, king of the gods. Obelisks were often carved out of single blocks of granite, from Aswan. They were transported on enormous wooden barges, and earthen ramps were used to raise them into position. The tallest obelisk that has survived was erected by Tuthmosis III, and is now in the Piazza San Giovanni in Laterano in

19

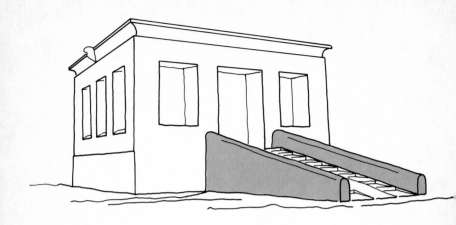

▲ In the small pavilions built as a series of shrines within a great temple complex the structure was closely related to the building's ceremonial use. At the religious festivals regularly held at Karnak for example, in honour of ·the major Egyptian deities, a procession would enter by the ramp at one side of the building, make offerings, and go out via another ramp, symmetrically placed.

Rome. It is 31.92m high, not including the base, weighs about 460 tonnes, and was carved from a single block of red Aswan granite.

Private buildings in ancient Egypt were constructed from clay bricks, which were left in rows to dry in the sun. As a result, no complete private houses survive, though as models have been found, in tombs dating from the Middle Kingdom, we do know that they had either one or two storeys, with terraced roofs and sometimes a covered balcony. An example of an original layout does survive however, in the form of the village built to house the labourers working on the necropolis of Thebes (19th-20th dynasties). It shows a very dense system of town planning, with terraced houses and few connecting roads. Each house comprised a series of rooms arranged more or less in a straight line, while the village itself was built on an irregular rectangular plan. The houses mostly had three rooms, with the kitchen and storeroom at the back, sometimes with a cellar, and at the front a sitting room or bedroom, often with a central wooden column.

Another village of this type has been found close to the necropolis at el-'Amarna. It forms a square 70m from one side to the other and is divided into six parallel blocks separated by five streets. The fact that this ordered plan has not been modified in any way suggests that the village was inhabited only for a short time.

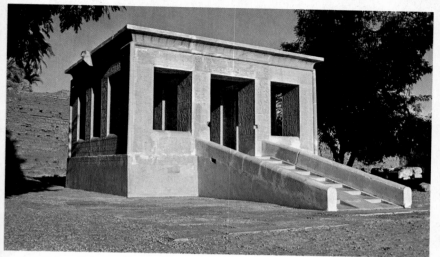

▲ The pavilion of Sesostris I at Karnak was built during the 12th dynasty, in about 1970–1925 BC. The building was demolished by Amenophis III, who used the stones to build the third pylon of the temple of Amen. It was rebuilt in AD 1937–8.

A few scattered remains of buildings, such as the royal palaces at Malkatta, in western Thebes, and at el-'Amarna, and the plans of the villas at el-'Amarna inhabited by high dignitaries and priests, are another source of information about secular buildings in ancient Egypt. Most of these date from the New Kingdom, but we also have the ruins of a whole Middle Kingdom city at el Lahun, in the Fayyum area, a few miles south of Saqqara, dating from the time of the 12th-dynasty pharaoh Sesostris II. This settlement had brick-built dwellings lived in by members of various social classes, arranged in districts bounded by a network of roads laid out at right angles. The houses lived in by the 'mayor' and other important people measured up to about 60 by 45m, and had a central courtyard, a pillared meeting room, usually with four columns, and rooms grouped into small apartments, as well as a kitchen and storage area. The columns were made of wood and rested on stone bases.

The 12th dynasty also saw developments in military architecture. Mighty fortresses were built, mainly in the south for defence following Egyptian territorial expansion into Nubia. The most common type was a fortified camp in the form of quadrangles with towers both in the central enclosure and at the outer corners.

Among Egyptian palatial architecture, remains dating from the New Kingdom are interesting for their complex

yet functional design. They were usually built well away from towns and temple areas and consisted of a whole series of buildings – the residence of the pharaoh and his family, the residences of the court officials, and one or more temples dedicated to the most important deities and the personal deities of the pharaoh. The overall area of the royal palace of Amenophis III (18th dynasty) at Malkatta included a temple to Amen and a district for the craftsmen working for the court. This area was divided by straight roads, though the plan was not quite as rigid as at el Lahun. As usual, this settlement or complex was built in brick, so only the general outline of its plan has survived. The columns and ceilings were made of wood, and stone was used only for ornamentation round the doors. The walls were covered with plaster

▶ The term 'false door' is used for a funerary stele — an upright block of masonry — placed inside a mastaba. It took the form of a blocked-up door, through which the dead were said to pass on their journeys between life on earth and the afterlife, and was also the place where offerings were made to them. In some examples the figure of the dead man himself stands in the doorway. The door varied in size depending on the importance of the tomb — it could be as little as about 50cm but might also be huge.

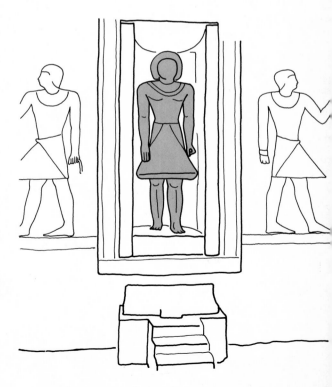

mixed with straw and decorated with paintings of plants, animals, and birds.

The huge and elaborate royal palace of Amenophis – Akhenaten at el-'Amarna is one of the finest examples of secular architecture in the whole of antiquity. It was built on the south side of the great temple of Aten and continued along the banks of the Nile in a series of different buildings. The pharaoh's official residence consisted of a vast hypostyle hall with 510 columns, leading into a throne room. His private dwelling was a separate block, linked to the rest by a passageway that crossed a great royal road in such a way that the whole building lay on two straight axes. The palace also included two harems, two gardens, temples, chapels, and individual apartments.

▶ The false door of Mereruka at Saqqara, with an image of the dead man in the doorway. During the funeral ceremonies the priest would recite special formulae to bring the statue back to life, the idea being that the dead man would then be magically 'present' to accept the offerings made to him.

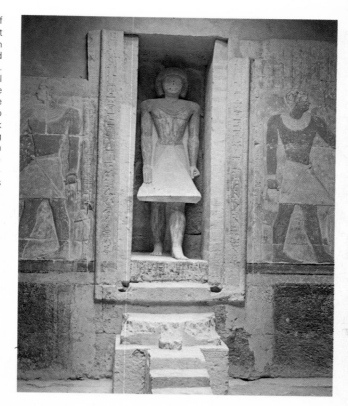

Sculpture

Egyptian sculpture represents one of the high points in the history of civilization, not only because of the large quantity of work produced but because the quality was so consistently high and the subject-matter was so uniform, even over a period of three thousand years.

Yet as artists did not sign their work, we know virtually nothing of the sculptors who created these masterpieces. The few exceptions include Tuthmose and Iuty, both in the second half of the 18th dynasty. Tuthmose was chief sculptor to Amenophis IV – Akhenaten, while Iuty worked for the queen mother, Tiye, Amenophis III's widow. Some of the finest sculptures from this period, including the famous portrait of Nefertiti, wife of Amenophis IV, were discovered in Tuthmose's workshop.

▶ By the beginning of the Old Kingdom rigid rules had already been worked out governing the depiction of the human figure. They laid down the various positions that could be used for portraying a person, depending on his or her social class. The gods, the pharaoh, and various dignitaries were allowed two poses – walking forwards and seated.

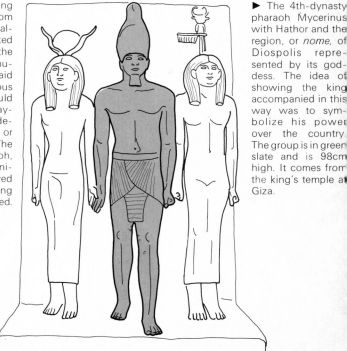

▶ The 4th-dynasty pharaoh Mycerinus with Hathor and the region, or *nome*, of Diospolis represented by its goddess. The idea of showing the king accompanied in this way was to symbolize his power over the country. The group is in green slate and is 98cm high. It comes from the king's temple at Giza.

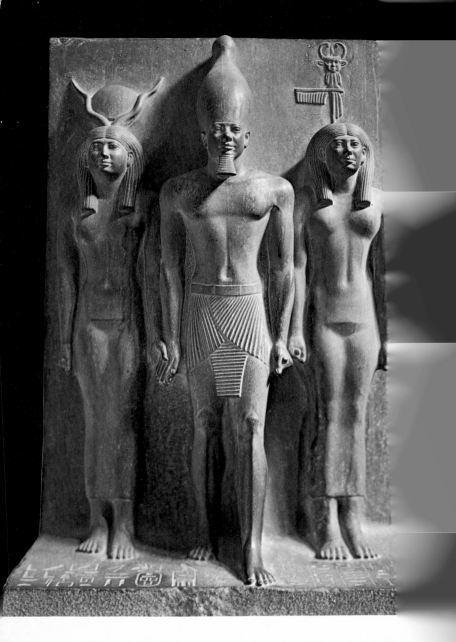

Symbol and form

During the Old Kingdom the use of statuary was closely bound up with funerary architecture. The statues placed in tombs or funerary temples were idealized portraits of the dead, since it was thought the magic of the image itself allowed the dead to take part in life on earth but also ensured that they would enjoy a peaceful life in the world beyond, even if their corpses were damaged or destroyed by grave robbers.

Religious practice required that the person depicted should be accurately identified; so his name and titles, and sometimes even pronouncements he had made, would be inscribed on the base or throne of his statue. The priests would also make the statue 'come to life' at

▶ The pharaoh Chephren, who ruled from 2558 BC, is shown in this statue with his head protected by the outspread wings of the falcon-god Horus. He is depicted in one of the standard positions laid down as acceptable at the time — seated, with his arms resting on his thighs. On the sides of the throne the papyrus and lily entwine around the hieroglyph for unity, with reference to the union of Upper and Lower Egypt; while the lion legs and heads symbolize the pharaoh's power. This method of depicting the sovereign (minus Horus behind the head) remained virtually unchanged over the next two thousand years.

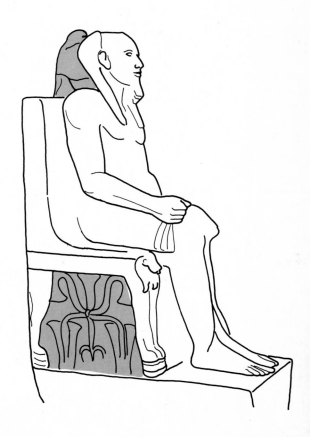

the funeral by reciting magic formulae. Since the dead sovereign was considered a recognized divinity, the royal statues in the funerary temples also served as cult objects to be venerated.

The most characteristic feature of Old Kingdom statuary was its expressive and descriptive power, in spite of the highly schematic and stylized forms that it used. The statue of Pharaoh Zoser of the 3rd dynasty, which comes from his tomb in the Step Pyramid at Saqqara, is a prototype of Egyptian monumental statuary.

The creation of royal statues increased during the 4th dynasty, and whereas Zoser's statue, for example, was inside a cubicle in the side of his pyramid, and thus not

▶ This statue of the 4th-dynasty pharaoh Chefren is in diorite and stands 168cm high.

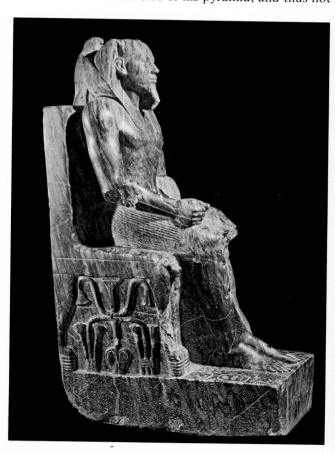

intended to be seen, 4th-dynasty statues celebrated the might of the pharaoh in full sunlight. The most famous example is the monumental sphinx at Giza, whose face is a portrait of Pharaoh Chephren.

Of the great 4th-dynasty pharaohs, Sneferu and Cheops were represented by statues of which only fragments now remain; but we do have some magnificent portraits of Chephren and Mycerinus. In the black diorite statue from his funerary temple at Giza, Chephren is depicted with a somewhat aloof expression, and as protected by the falcon-god Horus. He is seated on a throne with his forearms resting on his thighs, one of the traditional poses in Egyptian statuary. Various statues of Mycerinus survive, such as the one now in Cairo depicting him with the goddess Hathor and the goddess representing the district of Cynopolis (one of the geographical divisions of pharaonic Egypt). These works represent a step forward in that the majestic solemnity they share with the statue of Chephren at Giza has somehow acquired a more merely human quality.

Among the best surviving work of the 4th dynasty, other than statues of the pharaohs, are a pair of seated statues of Prince Rahotep and his wife Nofret. Their eyes are inlaid with quartz; and the prince's body is red, while his wife's is golden yellow. They were both discovered in a tomb in Medum, a few kilometres south of Giza, and are now in Cairo Museum.

Fifth-dynasty sculptors excelled in statues of private individuals, such as the two painted limestone *Scribes* now in the Louvre and in Cairo, which were found in the necropolis at Saqqara, and the hefty *Village Mayor* (in fact Ka-aper, the chief lector-priest, responsible for the correct reciting of the rituals read from papyrus rolls), carved in wood and with inlaid eyes, also from Saqqara and now in Cairo.

All these sculptures of the Old Kingdom reveal a degree of artistic maturity. By this period precise rules for depicting the human figure had been worked out, and stylistic features had been evolved that remained substantially the same throughout the history of Egyptian art.

Under the First Intermediate Period, stone was not predominantly used for sculpture, perhaps for reasons of economy; and apart from a few small pieces in

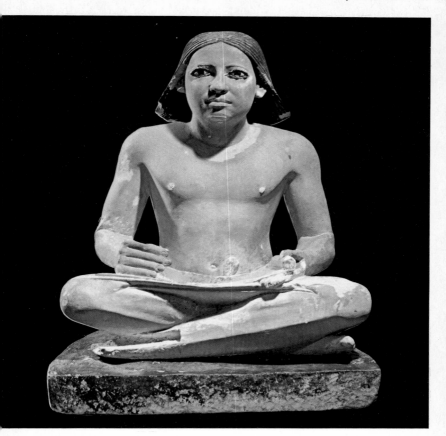

▲ ► This 5th-dynasty figure of a cross-legged scribe with a papyrus roll laid across his knees is executed in multicoloured limestone. His pose is the standard one laid down for representations of scribes. The shape of the wig, the most reliable way of dating Egyptian statuary, is typical of the Old Kingdom.

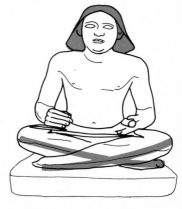

alabaster, wood was the most commonly used materia
The carving was more rough and ready during this era
and even the traditional proportions were not respected
Only a few sculptures have survived from this time, an
they cannot easily be dated. The most typical are painte
wooden models made to be placed in princes' tombs.

Middle Kingdom sculptors harked back to th
magnificent work of the Old Kingdom, yet at the sam
time aimed to reproduce realistic details in a way tha
would have been unthinkable earlier. Faces, in particula
were usually highly individualized. In work of the 12t
dynasty, a golden age for statuary in the Middle King
dom, the search for realism is even more obvious, an
royal statues, for instance, no longer have the abstrac
solemnity and feeling of divine peace that was so typica
of Old Kingdom figures. The portraits of Sesostris III an
Amenemhet III, with their care-worn faces and sunke

▶ This royal couple, from a 4th-dynasty tomb, are seated in one of the standard poses for people belonging to the ruling class.

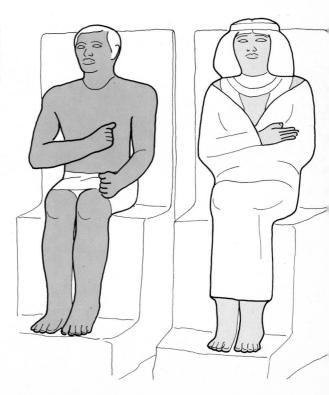

eyes, seem to cast doubt on the idea of these rulers'
unchanging and eternal authority, which had perhaps
been dented by the terrible period of civil wars that
followed the collapse of the Old Kingdom. Even portraits
of private individuals reflect this preoccupation with
realistic details, as in the black granite statue, now in
Boston, of Lady Sennuy, the wife of a nomarch, or
prince.

Although no specific schools of sculpture existed in the
Middle Kingdom, a number of groups with highly
individual styles did emerge. Some favoured the aesthetic
canons, or sets of rules, of the 5th dynasty, while others,
such as those which produced the portraits of Sesostris
III, placed an emphasis on realism. The portraits of
Amenemhet III are likewise highly realistic, though they
are more mannered than those of Sesostris II, also of the
12th dynasty, and Sesostris III.

► Prince Rahotep
and Princess Nofret.
The two 4th-dynasty
statues were dis-
covered in a tomb
n the necropolis at
Medum, south of
Memphis. They
were carved in lime-
stone and stand
120cm high. As well
as their poses, the
skin colouring —
brick-red for the
man and yellow for
the woman — was
also customary.

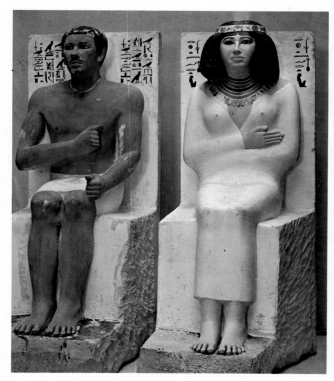

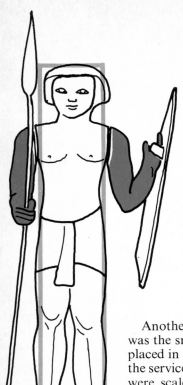

◀ One of the most interesting aspects of Middle Kingdom art, particularly from the 12th dynasty onwards, was the models depicting scenes taken from everyday life: fishing boats, craft workshops, weavers, butchers, and so on, and even groups of soldiers. Such models were made to be placed in tombs, where their function was held to be to perform essential tasks for the dead in the after life. The broadly rectangular shape of this figure reflects his function as one of several to be shown in formation.

Another typical product of Middle Kingdom artists was the smaller sculptures in painted wood, made to be placed in the dead man's tomb to make sure that he had the services he would need in the after-life. Most of them were scaled-down versions of everyday situations and activities, and depicted scenes of hunting and fishing, weaving, slaughtering of animals, troops on the march and in one case even herds of animals passing a house with a columned portico (it was found in the tomb of the chancellor Meketre at Deir el Bahri). These miniature sculptures also include one very beautiful 12th-dynasty representation of a bearer of offerings, now in the Louvre. She is carrying a basket on her head with a leg of meat for the dead man's dinner.

At the ending of the Middle Kingdom, after the expulsion of the Hyksos dynasties, established by princes of foreign origin settled in the Nile delta, the sovereigns of the 18th dynasty introduced a period when Egypt enjoyed greater political, military, and economic power than at any other time in its history. In the field of aesthetic achievement the New Kingdom, and the 18th dynasty in particular, produced an enormous amount of

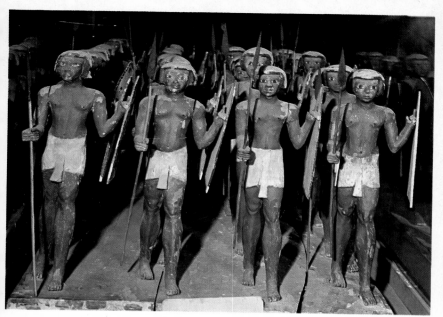

▲ Figures of lancers from the tomb of Masahti (9th–10th dynasties), governor of Assiut, in Upper Egypt. These are particularly fine examples because of their formal elegance and their impression of an army on the march.

sculpture, in widely varying styles. Temples and tombs were crammed with statues of royalty, divinities, and private citizens, while at the same time the traditional poses of the Old and Middle Kingdoms were superseded by a wider variety of subject-matter. Granite was used for life-size sculptures, and statues of colossal size were erected using limestone and sandstone.

Outstanding statuary from the early New Kingdom especially includes sculptured portraiture of Queen Hatshepsut. These works reveal an interest in reproducing the facial features of individuals, though they still adhere in many respects to the old restraints of idealization. One interesting feature of the new preoccupation with grace and lightness which they also show is that the heads of the sphinx dedicated to the queen were sculpted on feminine and delicate lines although she was depicted with an artificial beard and other typically masculine royal attributes.

Officials and even architects were now being portrayed in stone much more often than in the past, and their statues were even allowed into temple courtyards. Senmut, the architect who built the funerary temple of

Hatshepsut at Deir el Bahri, in a statue now in Cairo Museum is depicted in a squatting position, his cloak tightly wrapped about him, with the head of Princess Neferura, whose tutor he was, emerging as if from out of the cloak. The princess is also shown with him in other groups. Amenhotep, son of Hapu, Amenophis III's architect, was portrayed as a scribe, or in other words as an educated man, in two statues, both now in Cairo, which were once in the temple of Amen at Karnak; and of the elegant wooden statues, a bit smaller than life-size, made during this period to be placed in tombs, one of the finest, now in Turin, is of the royal architect Kha.

Within the traditions common at various times to the New Kingdom one in particular was mainly local. This was Amarna art, which originated at el-'Amarna in the second half of the 18th dynasty, and in particular during the reign of Amenophis IV (c. 1379–1362 BC). As we have seen, with the accession of Amenophis IV the cult of the sun god Aten superseded the traditional worship of several deities. The city of Akhetaten, where Amenophis moved the capital to be free from association with other gods such as Amen, developed rapidly, and the pharaoh gave personal encouragement to the artists working there. He decreed total naturalism – the artists were to depict what they saw, without feeling that they had to glorify it. Portraits of Amenophis IV do in fact show a man with an egg-shaped head, thick lips, puny shoulders and a pot belly (one example is the huge sandstone statue now in Cairo). The same bizarre details, verging on caricature, especially the unnatural length of the skull recur in portraits of the pharaoh's six daughters. Likewise the plaster casts and models of moulded masks discovered in the sculptor Tuthmose's house in el 'Amarna prove that he tried to create a true likeness of his sitters by accentuating their merits or defects. Two famous works found in his studio are the sculptured heads of Queen Nefertiti. One, now in Berlin, is in painted limestone – though with only one eye completed – while the other head, also unfinished and now in Cairo, is in quartzite.

The naturalistic element in Armana art left its mark even after Amenophis IV's successor Tutankhamen's reinstatement of the worship of Amen and an official return to the aesthetic canons of the past. The remarkable

▼ ▶ Amenophis IV–
Akhenaten (end of
the 18th dynasty, *c.*
1379–1362 BC) en-
couraged a natural-
istic style in the arts
that instead of em-
ploying the tra-
ditional idealization
stressed the physical
peculiarities of the
sovereign himself.
This sandstone
statue from the
temple of Aten at
Karnak depicts the
pharaoh with an
oval face, protruding
stomach and hips,
and very curving
thighs. He holds the
flail and sceptre, as
symbols of his
power, in what is
nonetheless a tra-
ditional pose.

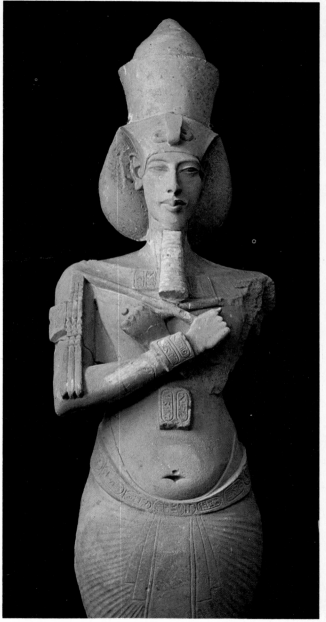

treasures, now in Cairo, from Tutankhamen's tomb which was discovered in the Valley of the Kings on the west bank of the Nile at Thebes, shows once again the influence of Amarna art, in a softer treatment in the depiction of drapery, for instance, and the styling of the bodies of some statuettes.

During the reign of Horemheb, whose career as a general ended with his becoming the last 18th-dynasty pharaoh, the traditional rules were once again supreme, though the brief but revolutionary influence of Amarna art continued to be felt throughout the 19th dynasty.

Enormous statues were characteristic of this period, good examples being the four huge portraits of Ramesses II at Abu Simbel, which were carved straight out of the rock; the statues on the façade of the temple of Nofretari also at Abu Simbel; and the large portraits from the temples at Karnak and Luxor.

Block statues, which had first appeared in the Middle Kingdom and had already been popular during the 18th dynasty, now became increasingly common. These were a form of sculpture in which a figure sat with its legs and

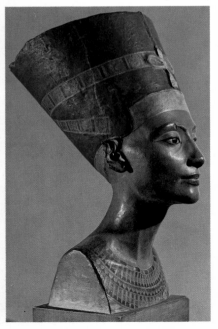

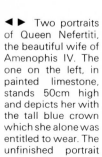

◀ ▶ Two portraits of Queen Nefertiti, the beautiful wife of Amenophis IV. The one on the left, in painted limestone, stands 50cm high and depicts her with the tall blue crown which she alone was entitled to wear. The unfinished portrait opposite, in quartzite and only partly painted, is 33cm high. It was discovered in el 'Amarna, in the workshop used by the great sculptor Tuthmose. The guidelines he used as he worked on the head are still visible

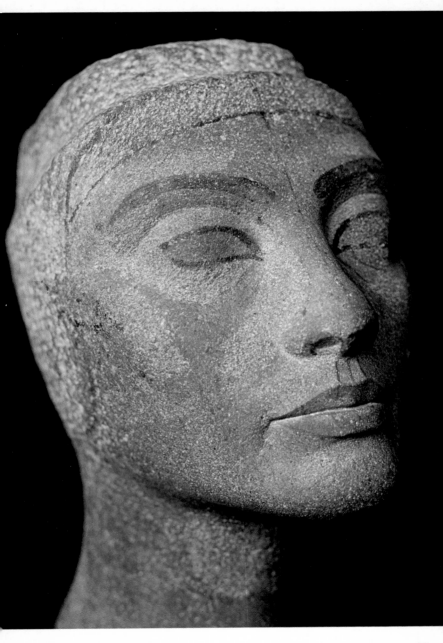

Symbols and accessories

▼ ▶ A black granite portrait of Ramesses II (19th dynasty). The king is wearing a ceremonial crown decorated with the sacred cobra, a symbol of royalty, and holds a sceptre in his right hand, in a gesture common to several ages of Egyptian art. He is also wearing a pleated linen tunic and sandals; and hieroglyphics inscribed down his robe give his name and his divine attributes. The whole statue stands 154cm high.

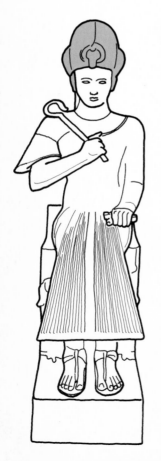

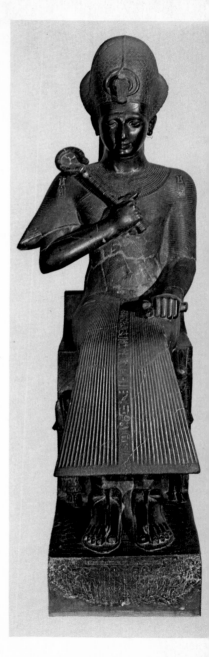

▼ This Theban dignitary of the 19th and 20th dynasties, whose name is Penmerneb, is holding an image of the god Amen as a sacred ram. His square-shaped wig and pleated tunic are typical of this period. An image of Queen Ahmose-Nofretari is carved on his shoulder. The inscriptions tell us that Penmerneb was employed at the royal necropolis at Deir el-Medina.

arms close to the body in such a way that they could not be distinguished from it. They include some of the most interesting pieces of Egyptian statuary, not least because of the many inscriptions on their smooth surfaces.

During the thousand years or so between the 21st dynasty and the end of pharaonic Egypt the most interesting pieces of sculpture were portraits of kings, high priests, and 'divine adorers' (priestesses), including the portrait now in the Louvre of Queen Karomama (22nd dynasty), 'Adorer of Amen', in bronze and gold.

By the time of the Late Period the dynasties often overlapped. For instance there were secular dynasties in the Nile delta, while the priests of Amen governed in Thebes. During the 26th, or Saite, dynasty, named after Sais, the town of its origin, artists returned to the forms of the past, using precious materials to create an elegant and delicate style that might be described as part of a renaissance. The statuary of the 25th and 26th dynasties was undoubtedly the most interesting sculpture of the Late Period. Portraits of the 25th-dynasty ruler Shabaka and his nephew Shebitku, and the priestess Amenirdis, all with Negroid features, are extremely powerful images

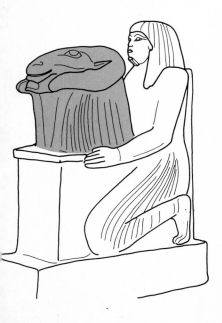
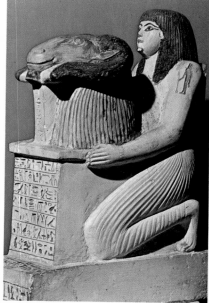

Symbols and accessories

▶ The design below the snake is a representation of the pharaoh's palace. The falcon, symbol of Horus, has alighted on the palace — a reference to the 'name of Horus', one of the five official titles given to the pharaoh who commissioned it and who was identified with this divinity.

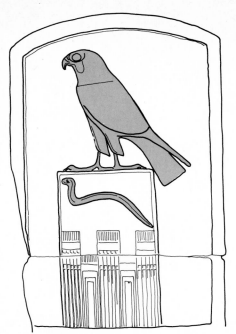

carved with decisiveness and something approaching harshness. The sculptors of the 26th dynasty tended to soften the faces of their subjects, reminding us of the priestly and majestic forms of the past, but also giving them a smile and a lightness that was absolutely new. Of the many examples, perhaps the finest is the statue now in the Louvre of the priest Nakhthoreb, which has all the characteristic stylistic features of this period.

The material most commonly used for the minor statuary of the period was bronze; and statuettes in this material, mostly depicting the gods in a wide range of costumes and poses, continued to be produced down to the time of the Roman conquest.

Throughout Egyptian sculpture generally in the periods described, inscriptions are clearly the most reliable means of dating most pieces, especially when they give the name of the pharaoh reigning when the statue was dedicated. If the pharaoh's name or some other historical reference is unavailable, the dating is based on the sitter's hairstyle or his wig, rather than his clothing which varied little over the centuries (though the New

► The Stele of Djet is 2.5m high and comes from Abydos, north of Thebes. It is called after a 1st-dynasty pharaoh whose name is depicted on it by the snake.

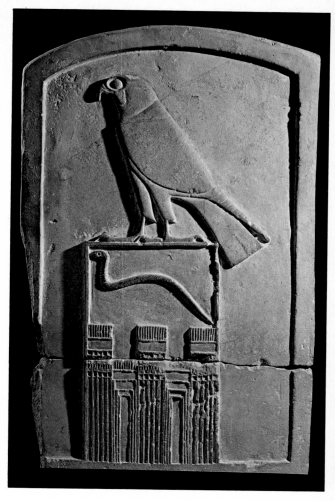

Kingdom did produce one or two specific styles). Fan-shaped wigs were typical of the Old Kingdom (as in the Cairo *Scribe*, for instance). So too were wigs in which tight curls formed circlets narrowing towards the top of the head, while wigs ending in a roughly triangular shape and marked with small diamond shapes were typical of the New Kingdom during the 18th and 19th dynasties. In the Saite period wigs were gently rounded on the shoulders and were usually plain and straight.

41

Painting

Egyptian painting began with ceramic decoration, using natural earth colours painted with thin reeds chewed at the end to spread out their fibres. Colour was in fact one of the most important elements in Egyptian art, not only in wall paintings but also on reliefs and in inscriptions, and even in architecture – for although the buildings that remain are now mostly in bare natural stone, they were originally brightly coloured.

The pictorial rules traditional to Egyptian art were laid down in the Old Kingdom, and the principles on which they were based came to be seen as decrees 'from the time of the gods', the mythical period of Egypt's origins. Under these rules the female body was usually depicted as bright yellow or pink, while the male body was a brownish-red. Backgrounds were generally white, except in the New Kingdom during the 19th dynasty, when they were occasionally yellow. But the most basic rule was that the human body must be stylized. The figure was

▼ Scenes of everyday work were very common on the walls of Egyptian tombs. Their function was to help ensure performance of activities the dead would need carried out in the after-life. The central figure is that of the foreman directing operations.

therefore painted as if it were being observed from several different viewpoints. The face was seen in profile, but the one eye shown looked straight ahead. The shoulders were shown from the front and the breast in profile, while the hips were seen from a three-quarter view. The legs were again depicted in profile.

During the Old Kingdom paint was applied both to figures treated in relief and to smooth plaster surfaces. The method was the same as it is today, in that the artist sketched his design on to the plaster with a brush dipped in diluted black ink and corrected as necessary until the composition was properly balanced. A scribe would then trace the inscriptions and an overseer would most probably check them for accuracy before the colour was added. This method of working is well illustrated by the unfinished tomb of King Horemheb (end of the 18th dynasty), which has some sections of wall decorated only with drawings, while others are already carved in low relief and yet others are at more advanced stages. Yellow and brown were obtained from the desert ochres; white from chalk; blue and green from the residue of melted-down glass paste or desert minerals ground up, with

▼ This relief of a shipyard on the Nile comes from an Old Kingdom tomb and shows labourers building a boat with rudimentary stone and copper tools. Although the scene is very lively, it does contain an element of stylization.

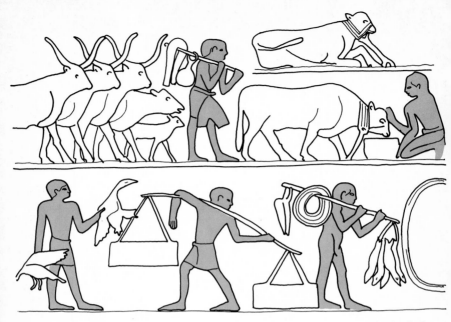

▲ Whereas the rules for pictorial depiction laid down standard poses and attitudes for people from the higher social classes, no restriction applied in showing the figures of manual labourers, since the important thing was to make it clear exactly what they were doing.

cobalt and copper as colouring agents; and black from lamp black.

The walls of Old Kingdom tombs, with their depictions of everyday life, provide fascinating information about the customs and mores of the period. Scenes showing people working in the fields, craftsmen and artists, crockery and furniture, even lilies being squeezed to extract their essence and oxen being slaughtered, give us a wealth of detailed first-hand information, particularly because the inscriptions enable us to identify the names used at the time for animals, plants, and artefacts. The hunting and fishing scenes that have been found are often very naturalistic and painted with great attention to detail, and among other items the geese from the chapel in a tomb at Medum, and now in Cairo, is one of the most lively examples of Old Kingdom painting. The composition is handled with great assurance and the sweeping brushstrokes and the range of colours and shading, never equalled in later periods of Egyptian art, make it a superlative example of the art of painting on plaster.

Reliefs painted during the 4th dynasty were richer and more subtle than during the previous dynasties and the

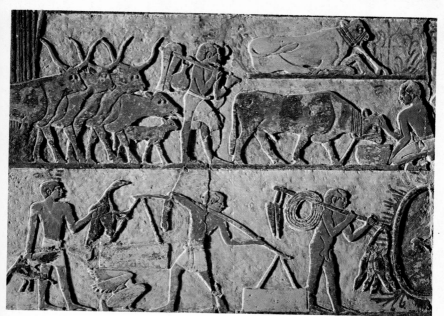

▲ Relief from a tomb at Saqqara, depicting farming scenes. Across the top the dead man's servants can be seen taking cattle to pasture and giving water to a bull, while in the bottom register other servants are carrying geese, food-stuffs with a yoke, and various implements.

subject-matter became increasingly lively, while during the 5th dynasty the restrained and austere descriptive style used during the reigns of Cheops and Chephren gradually disappeared altogether.

During the Middle Kingdom traditional subject-matter was still depicted, together with poses that had been in use in the Old Kingdom; for instance the height of figures within the same scene was made to vary, creating a perspective whose object was to make the most important personages stand out from the others. A wider range of colours was also used, with intermediate shading, instead of the primary colours used during the Old Kingdom. In general the use of colour was much freer. Wooden coffins also began to be decorated by painting.

During the 12th dynasty the stress was even more on realistic subject-matter taken from everyday life, but the standard of painting was often careless, with haphazard colouring and mistakes in the depiction of details. On the other hand some scenes, for example with such subjects as dancers and wrestlers, were almost like comic strips, with the figures' movements shown in a series of images.

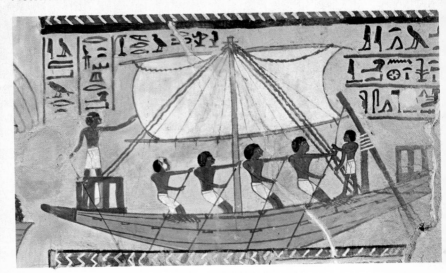

▶ The decreasing height of the oarsmen gives a slight feeling of perspective — it looks as if the boat is moving away from us, even though it is painted from one side.

The major surviving contribution made in pictorial ar by the New Kingdom is the wall paintings on a number o tombs in Thebes. These works cover the period o approximately four hundred years from the reign o Queen Hatshepsut (1503–1482 BC) to the end of the 20th dynasty (c. 1100 BC.). They are among the finest collections of paintings that have survived from antiquity. New Kingdom tombs rarely have painted reliefs, since th cliffs in the Valley of the Kings and the burial areas round about are made up of crumbly and not very compact rock that was unsuitable for the relief sculptures produced

◀ A boat with oarsmen, a detail from a pilgrimage scene painted in the tomb of Sennefer, a governor of Thebes during the New Kingdom who was buried in the necropolis at Thebes.

earlier. Painting on prepared plaster surfaces was thus a sensible and economical solution, especially once a wider range of social classes had acquired funeral rights and the middle classes were beginning to have their own decorated tombs, which were ornate enough to compete with those of the pharaoh and court dignitaries.

The style of drawing and composition developed as time went by. From the beginning of the New Kingdom there survive the reliefs from Deir el Bahri and the funerary temple of Hatshepsut. An advance in style is also evident in the tomb paintings of Tuthmosis III's reign, which display a liking for symmetry, and the use of stylized and austere poses and of opaque colours on dark blue or greyish-white backgrounds.

The nationalist revival following the expulsion of the Hyksos dynasties led to a return to the values of the past; and this affected art as well, though less apparently in the 18th-dynasty reigns of Amenophis II and Tuthmosis IV. Poses and compositions were now much softer and were painted in more graduated and transparent colours on to plaster which was mixed with straw to make it more cohesive. This style, generally described as 'fluid', represents a break with the formal past; but the subject-matter did not change. The paintings in the tombs of the Theban governor Sennefer, the court dignitaries Nakht and Menna, and Pharaoh Horemheb are famous examples from this period, all of them full of a sense of well-being that indicates a period of great political stability. Painting reached a high point with the reign of Amenophis III; specific aesthetic criteria were laid down, while a wider variety of colours was used and there was great purity of line and colour.

It was towards the end of this dynasty (c. 1350 BC) that the style known as Amarna art developed. As with sculpture, naturalism was now a keynote and in painted portraiture the physical defects of the pharaoh and his household were not glossed over.

Towards the end of the 18th dynasty, the Theban tombs of the vizier Ramose and the pharaoh Tutankhamen were built, exemplifying a return to an earlier, more formal style. One instance is the procession of retainers or household servants in Ramose's tomb, which is one of the finest examples of 'documentary' painting, and includes everyday objects (coffers, a bed with a head-

rest, vases for ointments and scents, sandals, a writing tablet) as well as the mourners, dressed in white pleated linen garments.

During the Ramesside dynasties – the 19th and 20th – the quality of painting was in some cases rather careless, but it nonetheless showed great freshness. Monochrome painting – that is, painting confined to one range of colours – was also attempted during this period. From the 21st dynasty the standard of Egyptian painting intermittently declined, though high standards were maintained at times in the painting of wooden coffins and in funerary papyrus scrolls.

We know not only the names but also the families of some painters, especially those working in the craftsmen's village of Deir el-Medina, near Thebes, who were among the leading exponents of New Kingdom painting. Thanks to records kept by accountants, and funerary inscriptions, we know the history of at least seven

▼ An 18th-dynasty painting of three ladies at a party. One of them is having her earring adjusted. The ladies' delicate profiles betray their aristocratic origins.

▶ New Kingdom painting was at its finest in the 18th dynasty, especially in Thebes. Typically the colour was applied swiftly and haphazardly within precisely defined outlines.

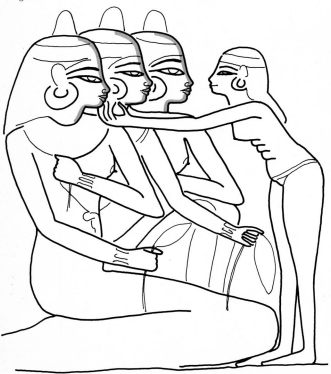

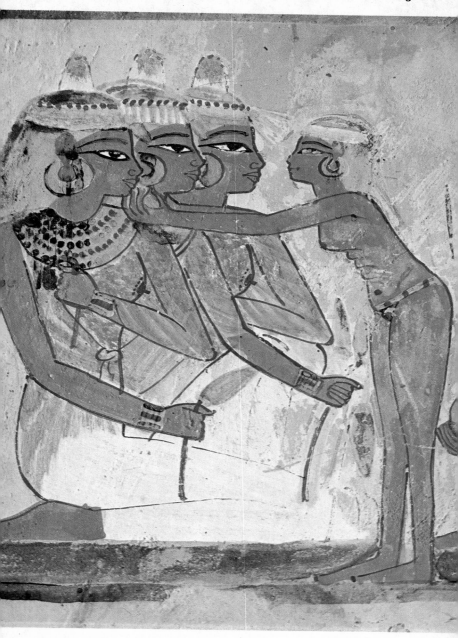

Tradition and form

▶ During the rule of Pharaoh Horemheb, at the end of the 18th dynasty, Egyptian art saw a return to traditional forms and subject-matter. But Amarna art did continue to influence artists to some extent: in painting for instance heads tended to be shown dispro-portionately large.

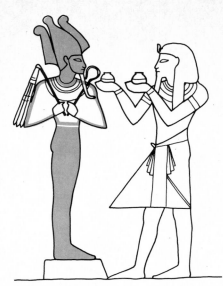

▶ A wall painting from Pharaoh Horemheb's tomb showing him offering libations of wine to Osiris, who is depicted as a mummy. This scene exemplifies the return at this time to traditional themes, including subjects such as sacred pro-cessions and li-bations intended to portray the glory of the pharaoh in the world beyond.

families of painters who handed down their art from father to son. For instance we know Pai lived during the reign of Ramesses II, and his sons Parahote, Paraemheb, and Hebra continued his work.

From the New Kingdom onwards, painted coffins and papyrus scrolls also became common forms of pictorial art – though during the Middle Kingdom painted coffins made of wood and cartonnage had already been pro-duced. Cartonnage was a substance similar in appearance to papier-mâché, and was produced by mixing linen, papyrus fibre, and chalk plaster. One beautiful mask now in the British Museum, shows how far the making of items in this material became a very sophisticated art. The face and head are covered with gold leaf, while the veil and eyes are turquoise and the inscribed pendants are in white.

During the New Kingdom, from the 18th dynasty onwards, as well as the more familiar coffins shaped like the human body we also have some straight-sided examples, which was in fact the most common form for wooden coffins in later periods. The surface was painted white or yellow, with inscriptions in black, and a painted face, especially during the Ramesside period. Some particularly elegant coffins were painted with vine shoots

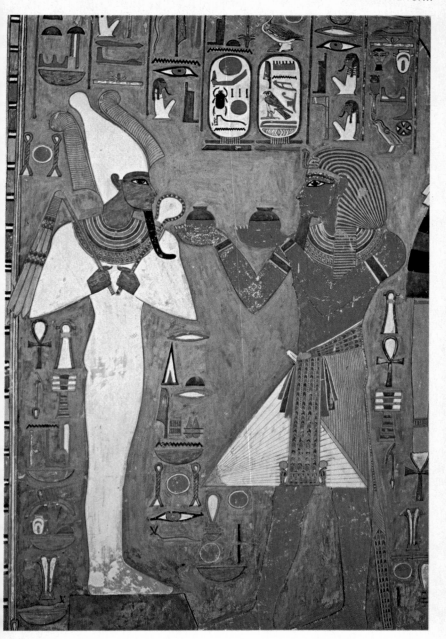

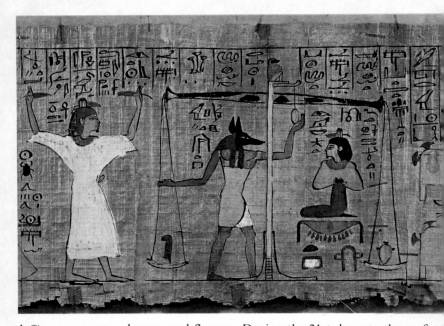

▲ The components in this scene of posthumous judgment are placed according to their importance in the narrative, with Osiris, weighing the heart of the dead man against a feather, placed near the centre of this precise and elegant composition. The hieroglyphs in the background are clear and carefully drawn.

leaves, and flowers. During the 21st dynasty the surface of the body might be covered with increasingly complex inscriptions, and ornamented with scenes of embalming, or of divinities such as Osiris, Isis – the goddess supreme in magic – Horus, Anubis, and Thoth – the god of learning, usually shown as an ibis, or at least with the head of one – all spirits ruling over the world of the dead. (The preservation, or mummification, of the body was essential to ancient Egyptian religious belief, since it was held that the dead person's spirit would need to inhabit the body.) Coffins in the shape of the human body scarcely changed down to the Ptolemaic era, the period of Greek Macedonian rule that began in the fourth century BC with Alexander the Great and lasted until the death of Cleopatra. Such coffins were made in wood or cartonnage, except during the Saite period when we find massive granite sarcophagi, fashioned with great expressive force.

On papyrus scrolls vignettes, or ornamental drawings, were a particular feature of Egyptian art, the most interesting being those on the scrolls of the *Book of the Dead*, a collection of magic formulae and incantations to

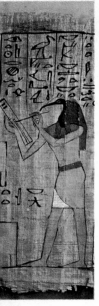

▼ One important scene on the papyrus scroll placed in tombs and commonly known as the *Book of the Dead* was the 'weighing of the heart'. The heart was placed on one dish of a pair of scales, with the court of Osiris looking on, while on the other dish lay the feather of divinity of Maet, goddess of truth. (The heart must not weigh more than the feather.) In this papyrus fragment the dead man is 'ideally' present, while Anubis, god of the necropolis, is doing the weighing, and Thoth, the patron of scribes, holds out his rush brush and his container for brushes and ink.

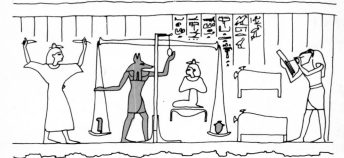

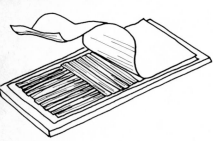

◄ Writing surfaces such as the one shown above being used by the figure of Thoth were made by placing rows of papyrus stems at right angles and hammering and pressing them to make a single layer.

help the dead in the complexities and difficulties of the after-life. The earliest surviving scrolls were made in the 18th dynasty, and such items became very common towards the end of pharaonic Egypt. In some cases the vignettes were large and alternated with the different sections of written papyrus roll; others were small and placed above the columns of hieroglyphics that made up the text. Some were simple stylized designs in black ink; others were coloured, in a way in keeping with the fact that the combination of text, picture, and colour were always held to have a specific magic significance.

Minor Arts

It would be fair to say that one of the ancient Egyptians
especial aims in this world was to prepare themselves for
the enjoyment of the after-life. The bulk of the evidence
we have of their art consists of the everyday items that the
dead were thought to take with them on their journey to
the west, to the realm of Osiris, god of the dead. Most of
this information comes from ceramics, articles of gold
and furniture, which are often astonishingly beautiful

During the Old Kingdom a great many vases were
produced, mainly in alabaster, and in all shapes and
sizes. Alabaster was worked with copper tools and
polished with abrasive pastes made from sand. Even
before the dynastic period craftsmen had shown a degree
of skill in producing plates and dishes in breccia and

▶ During the New
Kingdom craftsmen
working in the dec-
orative arts pro-
duced much fine
work in keeping
with the life of
luxury led by the
rich. Among the
funerary furnishings
for the pharaoh
Tutankhamen is
this jewelled relief from
the back of his
throne. It shows him
wearing the triple
crown which was a
feature in Egyptian
mythology of the
god Horus as a boy.
His queen's crown,
with the sun disc
surrounded by os-
trich plumes and the
horns of the sacred
cow, symbolizes the
return to the wor-
ship of Amen after
the monotheistic era
introduced by
Amenophis IV.

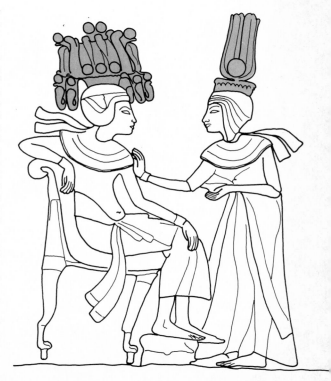

other hard stones that was especially remarkable considering the primitive means available to them. Alabaster superseded hard stone and was widely used because it was easier to work. In the subterranean storerooms of the pyramid of Zoser alone, 35,000 alabaster pieces were discovered.

The discovery of the tomb of Hetepheres, Pharaoh Cheops' mother, provided a particularly large amount of information about furnishings and jewels in the Old Kingdom. A garden pavilion covered in gold foil, a litter, a bed, an armchair, and other articles, including jewellery, were all found there. Among the jewellery were included silver bracelets set with turquoises and cornelians arranged in the shape of butterflies, a motif which was used down to the New Kingdom.

During the 12th dynasty new techniques were introduced into the applied arts from abroad, mainly from

▶ A sheet of gold decorated with glazed ceramic and coloured glass and embossed with portraits of the 18th-dynasty pharaoh Tutankhamen and his wife Ankhesenamen. It comes from the throne found in the pharaoh's tomb in the Valley of the Kings.

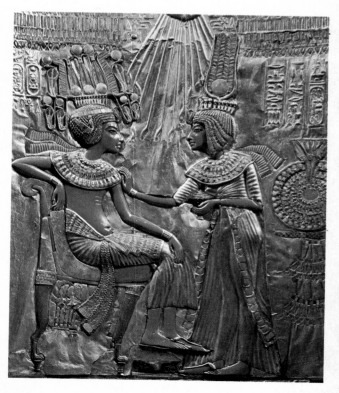

Crete and the Near East. Polished bronze mirrors with handles in the shape of papyrus flowers, and gold collars and pendants inlaid with glass paste and precious and semi-precious stones were made, and reveal great maturity of technique. Examples include the pendants of Sesostris II and Amenemhet III made for Queen Mereret. In these a miniature scene showing the king fighting his enemies is interwoven with amulets – charms worn as protection from evil – and inscriptions of the name of the pharaoh, with the vulture goddess Nekhbet looking on. The supreme masterpieces of this period are perhaps the crowns found at Dahshur belonging to Princess Khnumet. They are finely interlaced with gold thread, small turquoise and cornelian jewellery flowers, and engraved decoration.

Ceramic was another form of art that reached an advanced stage of development during the Middle Kingdom. It featured in particular a characteristic glazed

▶ The pose of Tutankhamen's image, with flail and sceptre crossed as symbols of authority, was a traditional one in Egyptian art.

▶ One of the series of coffins of Tutankhamen, which were made to fit one inside the other. The inside of the casket is covered with hieroglyphics on magical and religious themes.

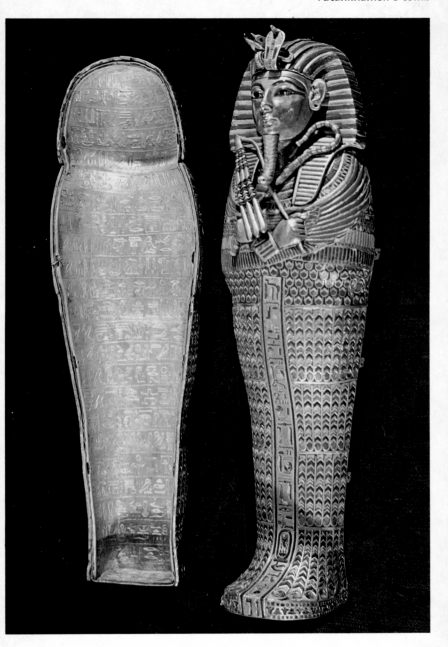

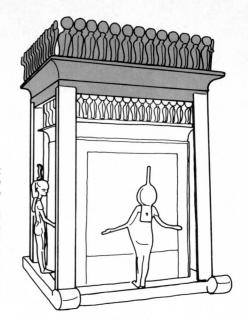

► On the casket made to contain the viscera of the pharaoh Tutankhamen, the horizontal carvings represent a series of sacred cobras. The casket's architectural appearance is enhanced by the pillars at each of the four corners.

turquoise decoration. Drinking cups, and figures of hippopotami, decorated with blue flowers on turquoise ceramic are typical of the 11th and 12th dynasties. In art, the hippopotamus was most probably a forerunner of the goddess Thueris, protectress of pregnant women, who was often depicted in later periods on amulets.

The splendid objects from the tomb of Tutankhamen give a good example of the state of the decorative arts during the New Kingdom. There are beds with gold inlay, a casket with its canopic vases – the containers for the internal organs of the dead king – painted caskets with jewels, a superb gold mask, and vases in alabaster and hard stone. The beds, of which there are three, are made of carved and gilded wood, decorated with images of a sacred cow and lioness, and Ammut, the hippopotamus goddess. Beds were among the most important pieces of furniture in the houses of Egyptians of the upper classes, and examples inlaid with ivory can be seen in illustrations dating from the earliest dynasties. The frame was set high off the ground, with claw feet in the shape of animal paws, either lions' or bulls', and the upper part decorated with carved and stylized animal heads.

Apart from beds, the most common pieces of furniture were chairs; low tables; and coffers and caskets, which were used to store everything from fabrics to documents, games, and cosmetics. Chairs, which were made with and without backs, were built on similar lines to beds, especially the legs, which again were carved in animal shapes. From the 5th dynasty onward a fairly low, straight or curved back was often added to the seat. In the earliest periods chairs were used only by the rich; but they became more common in the New Kingdom, while at the

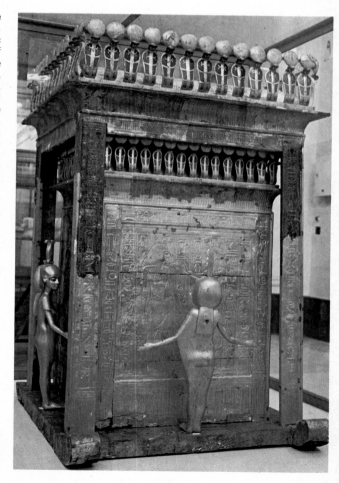

► The casket made to contain Tutankhamen's canopic vases, for burial of his inner organs. The goddesses Isis, Neith, Nephthys, and Selkis stand guard over the wooden casket, which is carved to look like a temple and covered with gold leaf. Inside was a somewhat similar structure in alabaster, and the four miniature vases were put inside that. The surfaces of the outer casket are covered with inscriptions consisting of protective religious formulae.

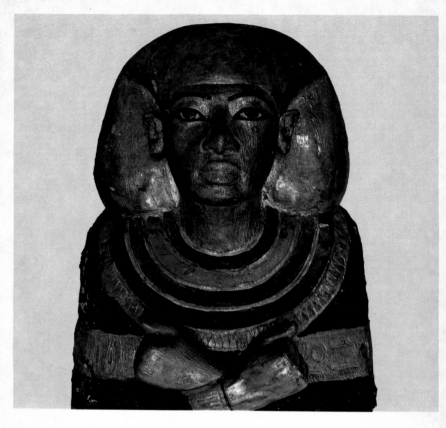

▲ A gilded and multi-coloured wooden coffin dating from the 6th century BC.

same time furniture became increasingly elaborate, with carving, inlays, and the greater use of precious materials.

Ceramic was used during the same period mainly for amulets in glazed blue and green made to ornament ushabti. These were miniature funerary figures intended to take the dead man's place in performing the most unpleasant tasks in the after-life. They were often engraved with inscriptions from the *Book of the Dead*. The enamel used for them was a mixture of siliceous sand with calcium carbonate, which was coloured during the firing process by adding copper oxide. Although ushabti did feature in the Middle Kingdom tombs, the finest examples date from the New Kingdom, and they were most commonly produced during the Late Period.

▲ Carved coffins shaped as an individualized image of the dead person were frequently common in Egyptian funerary art. The shape of the wig, rounded at the sides, is typical of the Saite period.

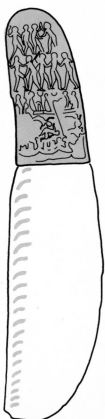

▶ A flint knife with an ivory handle, from the third millennium BC. It measures 9.5cm in length. The detailed scenes carved on the handle in low relief depict one of the early struggles for power in the Nile valley.

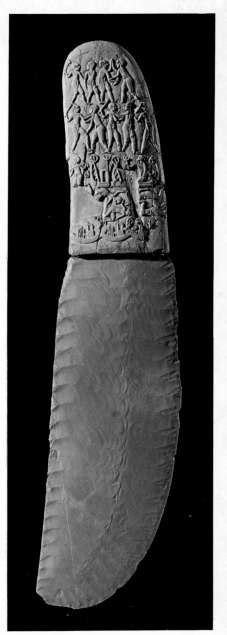

61

Glossary

Amulet: a charm worn to ward off evil.

Architrave: a moulded frame around or above a door or window.

Block statue: a type of statue, generally with inscriptions, representing a figure crouching with legs bent under the chin. The limbs, in such statues, are not easily distinguished.

Canon: in art, a general principle governing the form of a work.

Canopic vase: large carved container used in ancient Egyptian tombs to hold the internal organs of the dead man or woman. There were usually four of them. The name was derived by early Egyptologists from the city of Canopos, where Osiris, god of the dead, was venerated.

Capital: the upper part of a column.

Cartonnage: a cardboard- or papier-mâché-like substance, which was obtained by mixing linen, papyrus fibre, and chalk plaster.

Ceramic: any pottery substance, made by heating clay and other minerals at high temperatures.

Colonnade: a row of columns supporting arches or a lintel.

Façade: the external covering of each vertical face of a building.

Hieroglyph: the representation of an object that stands for a word or sound.

Hypostyle: a type of enclosed space with a roof supported by rows of columns.

Inlay: an ornamental substance embedded in another substance, for example the wood of a piece of furniture, so that the surface of the whole is even.

Mastaba: type of ancient Egyptian tomb with sloping sides and a flat top. The name comes from an Arabic word for 'bench'.

Monolith: a monument or column in the form of a single stone.

Monotheism: the worship of one deity only.

Necropolis: a cemetery or burial area, usually ancient.

Nemes: an ancient Egyptian form of head-dress with two strips of fabric falling forward over the shoulders and a short pigtail at the back.

Nome: an administrative territorial division of ancient Egypt.

Obelisk: a tall shaft of stone, usually square or rectangular in section, and tapering to a pyramid shape.

Papyrus: a marsh plant common, among other places, on the banks of the Nile.

Pilaster: a shallow column, rectangular in section, projecting from a wall.

Portico: a roofed area, open or partly enclosed, and often with columns.

Pylon: in ancient Egyptian buildings, a pair of truncated towers on either side of the gateway to a temple; also used in isolation as ornament or a boundary marker.

Sarcophagus: a stone coffin, often inscribed or sculpted.

Sphinx: a statue representing a lion's body with a human or animal head.

Stele: an upright stone slab or pillar, usually carrying inscription or other carving.

Ushabti: funerary statuettes intended to perform the more unpleasant tasks necessary in the after-life.

Vignette: an ornamental drawn detail with no definite border.

Bibliography

Aldred, C., *Akhenaten and Nefertiti*, Thames and Hudson, 1973. A first-class illustrated account of the Amarna period.

Aldred, C., *The Development of Ancient Egyptian Art*, Academy, 1978. A survey of the styles and purposes of statuary mainly but also reliefs and paintings.

Aldred, C., *Jewels of the Pharaohs*, Thames and Hudson, 1978. Techniques are clearly explained; materials used are well defined and styles and symbolism of individual pieces are described. Excellent colour plates.

Edwards, I.E.S., *Treasures of Tutankhamun*, Michael Joseph, 1974. A good introduction to the ideas behind works of Egyptian art.

Emery, W.B., *Archaic Egypt*, Penguin, 1967. Covers the formative years of Egyptian art and architecture, religion and culture.

Fakhry, A., *The Pyramids*, University of Chicago, 1974. Factual survey of pyramid-building through the whole of Egyptian civilization.

Lauer, J-P., *Saqqara*, Thames and Hudson, 1976. Describes tombs of the kings and nobles who ruled at Memphis.

Mekhitarian, A., *Egyptian Painting*, Skira, 1978. A well-written survey of the development of Egyptian tomb decoration.

Ruffle, J., *Heritage of the Pharaohs*, Phaidon, 1977. Extremely readable, up to date and well-illustrated introduction to Egyptian archaeology.

Sources

Cairo Museum: 24, 27, 29, 31, 33, 35, 37, 55, 57, 59, 60; Museo Egizio, Turin: 38, 39, 52; Louvre, Paris: 41, 61; Staatliche Museum, Berlin: 36

Index

Numbers in italics indicate illustrations.

Index

Photocredits

Borromeo: 33; Cirani: 5 (above and below), 51, 59, 60; Mauritius: 19; Publifoto-Kessel: 16; Rizzoli: 61; Stern: 9; Stierlin: 15, 21; Titus: 4, 7, 11, 12, 13, 17, 23, 25, 27, 29, 31, 35, 36, 37, 38, 39, 41, 43, 45, 46, 49, 53, 55, 57.